Handmade
Punched
Greetings Cards

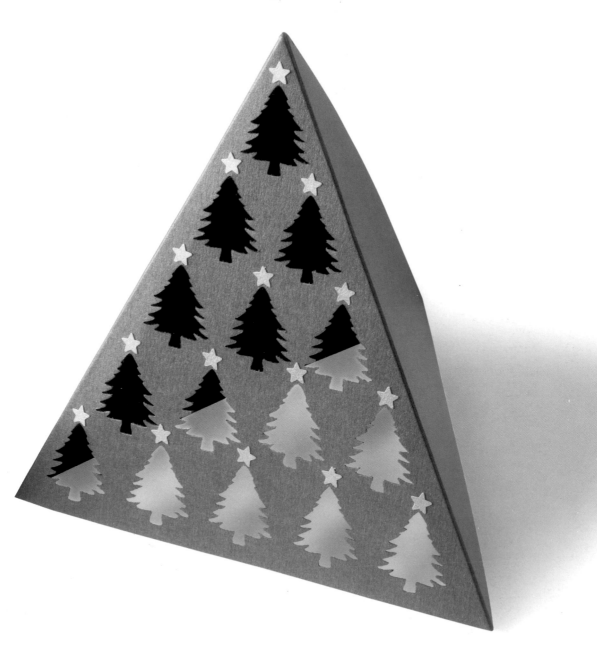

*Thank you Mervyn, Matt and Owen for putting up
with me and all the mess while I wrote this book –
I could not have done it without you all.*

*Thank you to my good friend Sue for her amazing
card ideas that springboarded and created several of
the cards in this book.*

*I dedicate this book to Mervyn, Matt, Owen,
Mum, Dad, Shine and to the memory of Laurie.
Thank you for your continued help, support and
enthusiasm in seeing this book published.*

*To all you punch fans out there
– enjoy and get punch crazy.*

Handmade
Punched
Greetings Cards

Julie Hickey

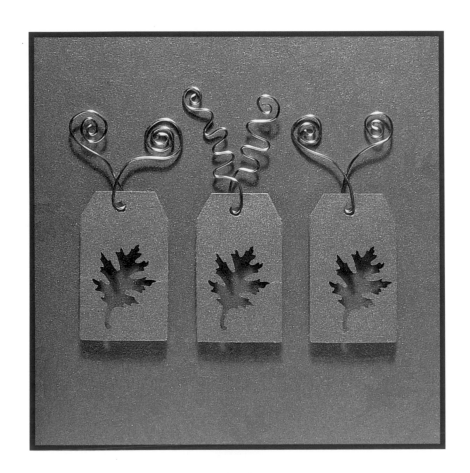

SEARCH PRESS

First published in Great Britain 2003

Search Press Limited
Wellwood, North Farm Road,
Tunbridge Wells, Kent TN2 3DR

Text copyright © Julie Hickey
Photographs by Roddy Paine Photographic Studios
Photographs and design copyright © Search Press Ltd. 2003

ISBN 1 903975 75 1

The Publishers and author can accept no responsibility for any consequences arising from the information, advice or instructions given in this publication.

If you have difficulty obtaining any of the equipment or materials mentioned in this book, please write to the Publishers, at the address above, for a current list of stockists, including firms which operate a mail-order service.

Publishers' note
All the step-by-step photographs in this book feature the author, Julie Hickey, demonstrating how to make handmade greetings cards. No models have been used.

ACKNOWLEDGEMENTS

I want to say a huge 'thank you' to the following, without whose generosity this book would not have happened:
Pete Smith at Crafts Too and Peter Clark at Kars & Co. who both supplied punches; Margaret Smith at Kuretake who supplied the thumbnail punches from EK Success; and last but by no means least, Judith Brewer at Woodware Toys and Gifts, who supplied so many of the punches, the plastic punch aid and Liquid Pearls used in this book.
Thank you to Crafty Inventions for their metal punch aid, the 'Punch Pal', which is an amazing product.
To Presto Craft for allowing me to use the Wonder Press, which will take punching to new limits.
To Frasier at Xyron for the generous and speedy delivery of the Sticker Machine and all the supplies to go with it.
My favourite dimensional paint came from Appli-Craft; thank you Marti and Vee for Appli-Glue!
The sparkle on my cards is from flat-backed crystals which came from my good friends, Lyn, Jamie and Lucy at LA Designs.
My biggest thank you has to go to Sue, Richard and Rose at Craftwork Cards, who have been so generous with all the cards they supplied for my book. Their fast and efficient service certainly helped to make each project run smoothly. Richard, I also have to thank you for pushing my book at every opportunity – what would we do without you!
A personal thank you goes to Jill Whitlock and Helena Daniels for always treating me to such wonderful goodies which appear in many of the photographs in the book.
I want to thank the team at Search Press, especially Roz for giving me the chance to create this book; to Sophie for her hard work and speedy production of all the drafts; and to Juan for his fantastic design skills – the cards look amazing. Thank you to Roddy Paine for his patience and attention to detail during photography, which resulted in fabulous pictures of my cards. Thank you Jill, too, for keeping the coffee flowing so well.

Contents

Introduction 6

Materials 8

Techniques 12

Daisies With Wire 16

Leafy Luggage Labels 22

Handbag 28

Christmas Trees 36

Mosaic Card 40

Further ideas 46

Index 48

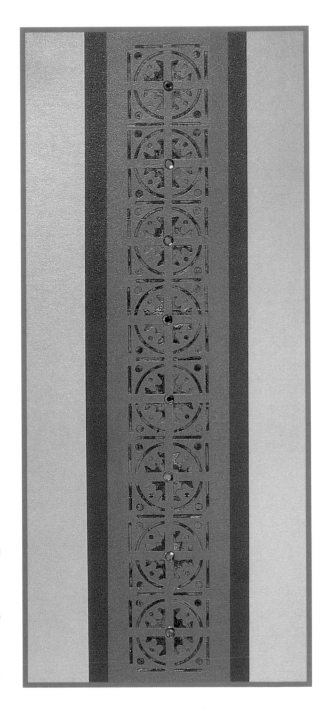

Introduction

I can't remember when my love affair with punches began. I was always an avid stamper, and I used to think that punches were only for making animal shapes such as rabbits. Then I was introduced to the daisy punch, and I was totally hooked!

I love the simplicity of punched cards: the variety of effects that you can create by using different papers and cards, and the fact that you can mix them with wire, beads and threads to give added interest.

There is so much that you can do with just a square punch: you can use the squares to mount on to or create a simple square or a rectangular aperture. You can then use another punch to punch the square waste from a card, creating a square with a shaped hole in it.

There are so many different punches available now, and I feel sure that whether you are a punch addict or just embarking on your journey of discovery, you will find many hints and tips in this book to help you get more from your punches.

Enjoy the projects on the following pages, use them to get your creativity flowing and create your own fabulous punched greetings cards.

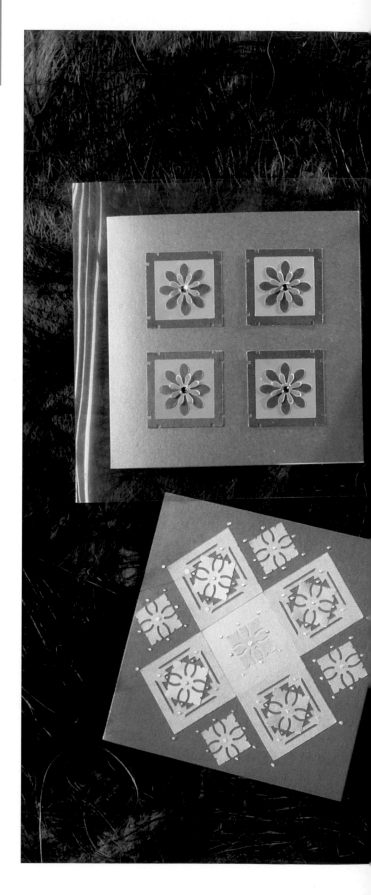

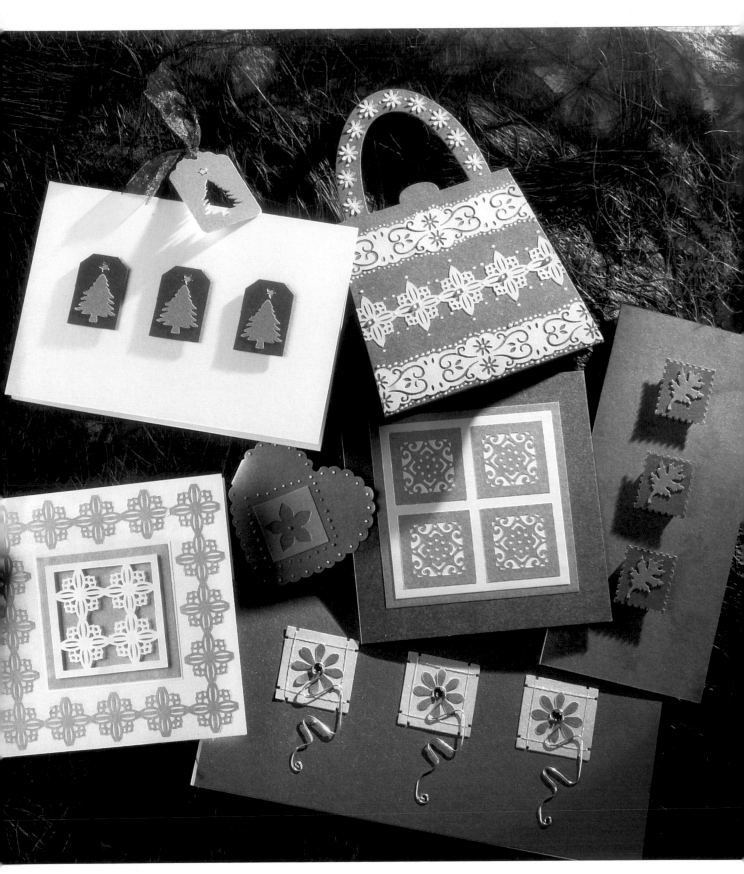

Materials

Punches

Punches come in so many different shapes and sizes now. From single hole plier punches to small, medium, large and even super giant punches, long reach punches, thumbnail punches and fabulous border punches. The design of the punch can be simple like a circle or square or far more intricate like the mosaic punches.

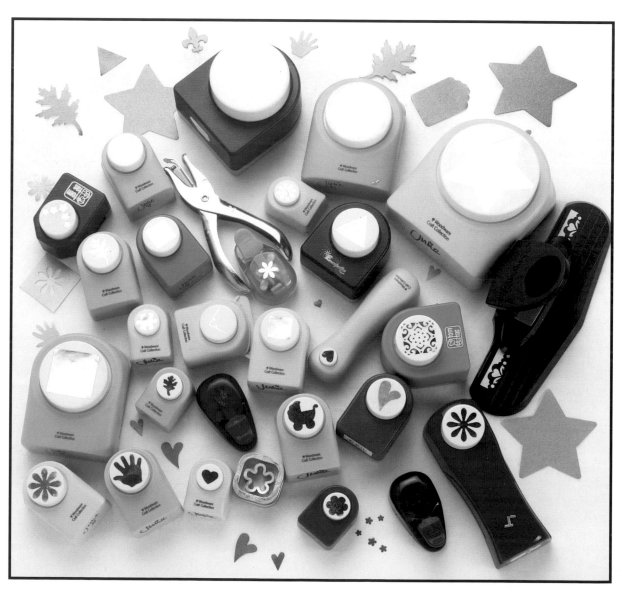

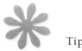

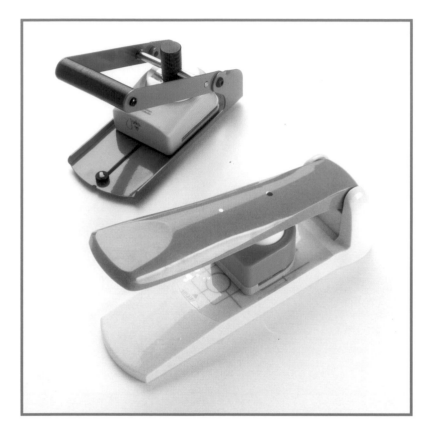

Punch aids

If you have problems with your hands or find punching difficult, there are some great punch aids on the market and they will certainly make punching much easier. You can choose from wooden, plastic and metal aids, and they all accommodate various sized punches. The metal punch aid will enable you to punch through much thicker card, metal and even shrink plastic. This aid also comes with templates to create patterns with your punches. These are easy to follow and allow you to get more from the punches.

Long reach punch system

This is the only long reach punch system that enables you to punch up to 15cm (6in) into your card. This means that you can punch anywhere on your card. The system uses punch dies in various shapes and you can change the orientation of the punch die, giving four separate positions. The system also has interchangeable punch dies and embossers, so that you can create shaped holes or embossed images which will appear raised on your card.

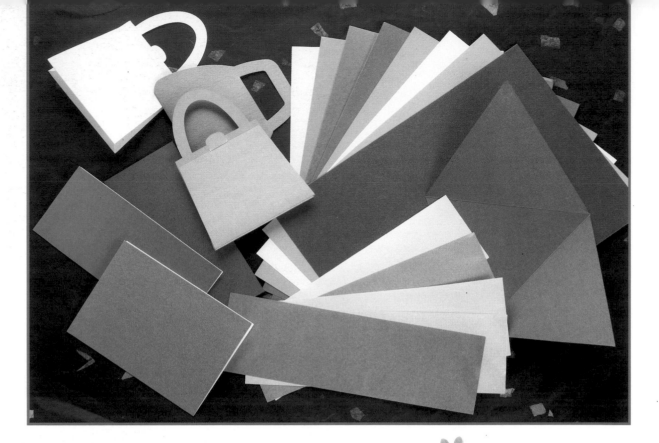

Papers and card

There is a huge variety of beautiful cards, papers and card blanks available, including card blanks in unusual shapes such as the handbags shown here. You can also use fine handmade papers for punched cards, but I find it best to spray mount them on to photocopier paper before punching them out.

Tip
Some papers may tear or get jammed in the punch. If this happens, try sandwiching them between two sheets of photocopier paper. You should get crisp punches this way.

Decorative items

I love to add embellishments to my cards to give texture and dimension and to bring the cards to life. Scour the shops for threads, ribbons, beads, crystals or charms, in fact anything to give added interest to your cards.

Charms, beads, flat-backed crystals, flower eyelets, decorative string, wire, dimensional paint, dimensional glue and threads can be used to embellish punched cards.

Other items

A **paper trimmer** is used to cut paper and card to size.

A **sticker machine** applies adhesive to the reverse side of small punched items. It works by sticking items to a backing paper with a clear film on top, which is then removed.

Soft-grip scissors are used to trim and cut paper, cards and threads.

Round-nosed pliers are used to bend and shape wire, and **wire cutters** must be used to cut it, as cutting wire will damage your scissors. Wire cutters also give a cleaner cut.

3D foam squares are used to mount punched shapes to raise them up off the card.

Inkpads are used with stencils to sponge coloured shapes on to cards. **Sponges** can also be used to apply ink.

A **ruler** is used for measuring prior to cutting.

A **paper pricking tool** is useful for unblocking the top of a dimensional paint bottle. I also use it to apply glue to the back of wire accents and beads.

A **silver pen** or **pencil** can be used to mark dark coloured cards.

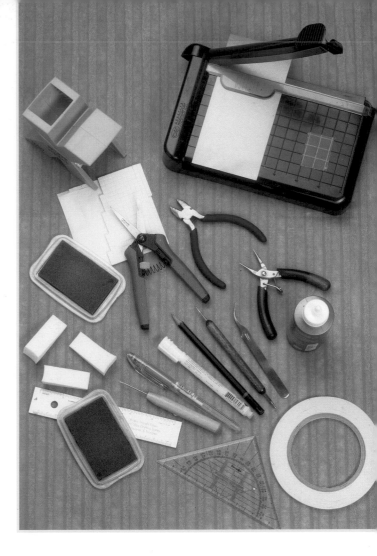

I always spray mount into an old cardboard box, which is now quite sticky. This helps when I am spraying small items, which might otherwise fly away during spraying. Hold the box in an upright position, hold the can 25–30cm (10–12in) away and apply a fine mist to your work.

A **glue pen** is used to stick small punched items on to cards.

A **stencil embossing tool** is used to firm down the edges around the sticker machine paper and film before you remove the film.

All-purpose craft glue is used to stick embellishments to cards.

Spray mount is used for sticking fine papers and vellum to cards so that they lie flat and the glue does not show through.

Tweezers are useful for placing small punched shapes or beads.

A **set square** is used to position items correctly on a card.

Double-sided tape is used for mounting, and for sticking larger punched items to card.

Techniques

Punches are very versatile: you do not have to use them just for the shape that they punch. A square punch can create square or rectangular apertures in cards, or punched squares or diamonds for layering other shapes on to. You can punch out different shapes and use the square punch upside down around the hole to create a square with a shaped hole in it.

Tip
When using the punch upside down, push down gently until you feel the punch bite, position your paper or card, then push all the way down to punch out the shape.

Making a square aperture

1. Work with the card open. Put the punch in from the top, as far as it will go. Judge by eye that the punch is in the middle of the card, or use a set square to measure it.

2. Make a second aperture at the bottom of the card, in the same way.

3. You can not punch out a third square in the middle, as the punch will not reach that far. Punch out a square in a different colour and place it in the middle of the card as shown. Stick it in place with double-sided tape.

Making a rectangular aperture

1. Work with the card open. Put the square punch in from the side and line up the top of the card with the edge of the punch. Push the punch in as far as it will go and punch.

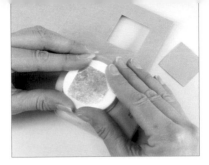

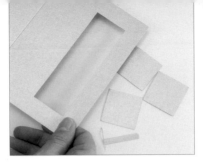

2. Line the punch up in the same way at the bottom of the card and punch out another square.

3. Punch two overlapping squares in the middle of the card to finish the long aperture.

Making a three aperture card

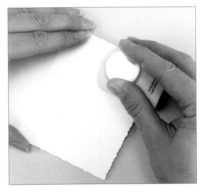

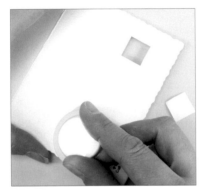

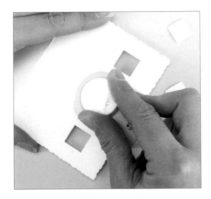

1. Open the card. Line up the small square punch with the top of the card and punch out a square.

2. Do the same at the bottom of the card.

3. Centre the punch between the two apertures by eye and punch out the middle square.

Making an opening card with a punch

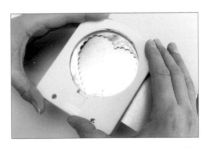

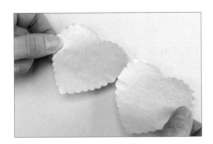

1. Fold a piece of paper and place it in the upside-down punch, so that you can see clearly where the punch will cut the shape.

2. Make sure that the fold in the paper is inside the punch area. Here the fold can just be seen on the left-hand side of the heart shape.

3. When the shape is punched, the fold will remain intact, and the shape will open out to make a gift tag or small card.

Using the waste

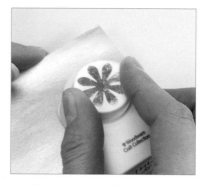 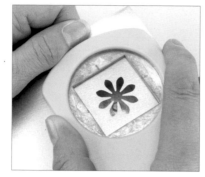 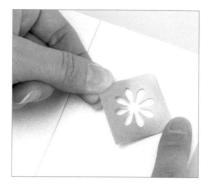

1. Punch out a daisy and keep the waste paper out of which it has been punched. The punched out daisy itself can be used for another card.

2. Hold a square punch upside down and feed in the waste paper. I have marked the centre points on the metal underside of my punch. Line the daisy petals up with the marks.

3. Punch out the square. The daisy-shaped hole will be centred in the middle of the square.

Border punches

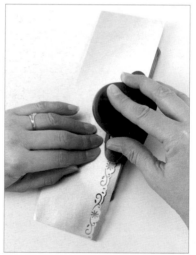 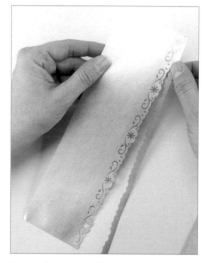 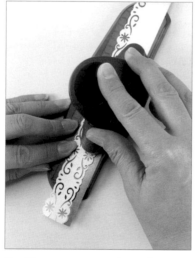

1. Place the paper in the border punch. Make sure it is pushed in and lines up with the back plate, and punch. Move the punched strip along and line it up with the pattern on the base of the punch. Punch again, line up again and punch until the whole strip is punched out.

2. When you have completed your border, pull off the waste paper edge.

3. You can cut strips of paper in different widths and use the border punch on both sides, as shown. I have found that a 3cm (1¼in) strip works well, but by altering the width you can achieve different looks.

The finished panel

Sponging through a stencil

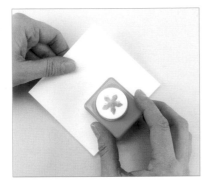

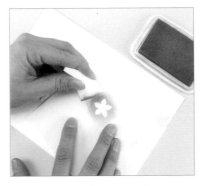

1. Punch a flower shape out of card to make a stencil. Many punches are great for creating stencils. Have fun discovering which shapes work best.

2. Position the stencil on your card, and using a piece of cosmetic sponge and an inkpad, sponge through the stencil.

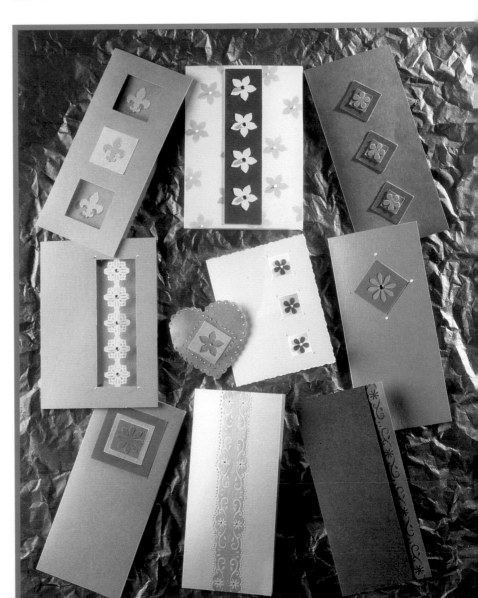

Here are some of the beautiful effects you can achieve using punches with the techniques shown.

Daisies With Wire

The first project had to feature the daisy punch! I have combined it with my second favourite punch: the square. I have used a special corner cutter on the squares, then wrapped them with thread. The stems of the daisies are made by bending and shaping wire to finish the look.

The template for the daisy stems

You will need

Daisy, square and corner cutter punches

Blackcurrant card blank, 10 x 21cm (3⅞ x 8¼in)

Blackcurrant and silver card

22g silver wire, round-nosed pliers and wire cutters

Double-sided tape

All-purpose glue and paper pricking tool

Dimensional glue

Glue pen

Silver metallic thread

Scissors

Set square

Purple flat-backed crystals

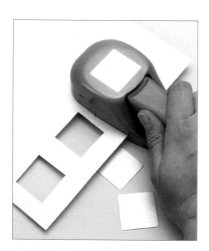

1. Punch out three squares from silver metallic card.

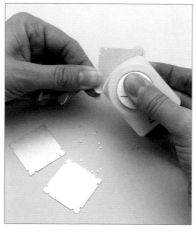

2. Use a square corner cutter to cut notches in each corner of all the squares.

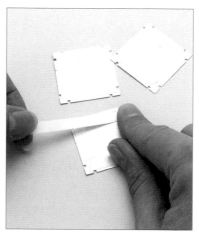

3. Put double-sided tape on the back of the notched squares as shown.

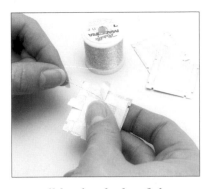

4. Pull back a little of the backing paper from the double-sided tape on two adjacent strips. Stick the end of some metallic thread to one of the strips, as straight as possible. Take the thread to the first notch.

5. Bring the thread round to the front of the square, wrap it round one of the notched corners, then take it down at right angles, wrap it around the next corner, and so on.

6. Wrap the last corner, which is also the one you started with, cut off the thread and stick the end to the double-sided tape in a straight line.

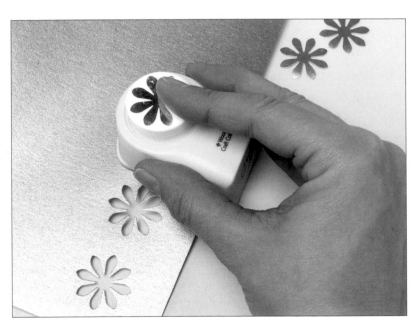

7. Punch three daisies from purple metallic card.

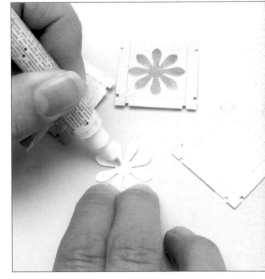

8. Apply glue to the back of the purple daisies using a glue pen, and stick them in the centres of the notched silver squares.

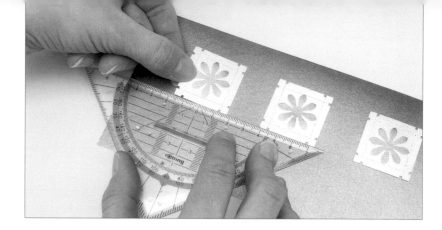

9. Peel off the backing paper from the double-sided tape on the silver squares, and stick them to the card. I use a set square that counts outwards from the centre to help me position artwork on a card blank.

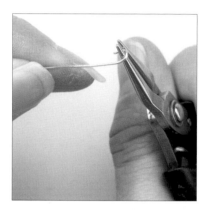

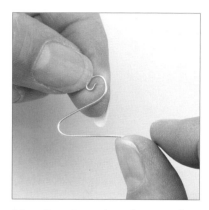

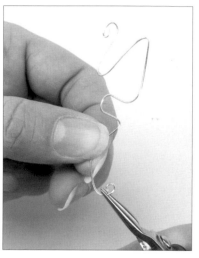

10. Cut a length of silver wire using wire cutters and use round-nosed pliers to curl the end.

11. Continue bending and shaping the wire using your fingers. Follow the template on page 16, or create your own design.

12. Make the final curl in the end of the wire using the round-nosed pliers.

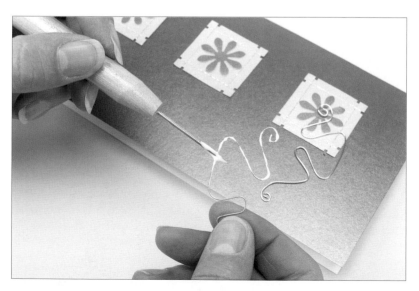

13. Apply all-purpose craft glue to the back of the wire shapes using a paper pricking tool or cocktail stick, and stick the wires in place as shown. It helps to place something heavy on the wire accents while the glue dries. A big punch is ideal.

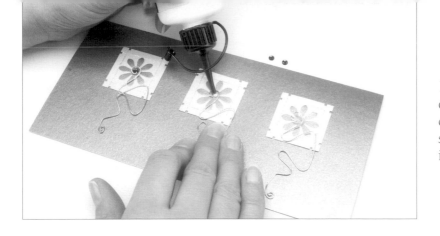

14. Place a drop of dimensional glue on to the centre of each daisy and stick a flat-backed crystal inside the wire coil.

I love this card: it is quick and easy to make, but the thread around the squares and the wire give it plenty of added interest. The sparkle from the crystals sets the daisies off beautifully.

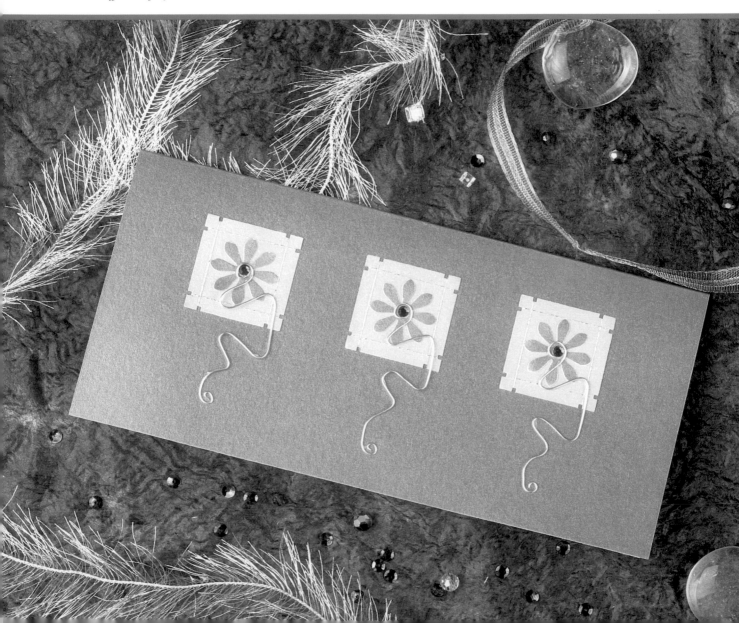

You can create great-looking cards by using pre-embossed card blanks and adding a daisy, crystal and wire. The squares placed at an angle make diamond shapes, which totally change the finished look. You can buy flowerpot punches, or, as in the card on the far right, draw and cut your own.

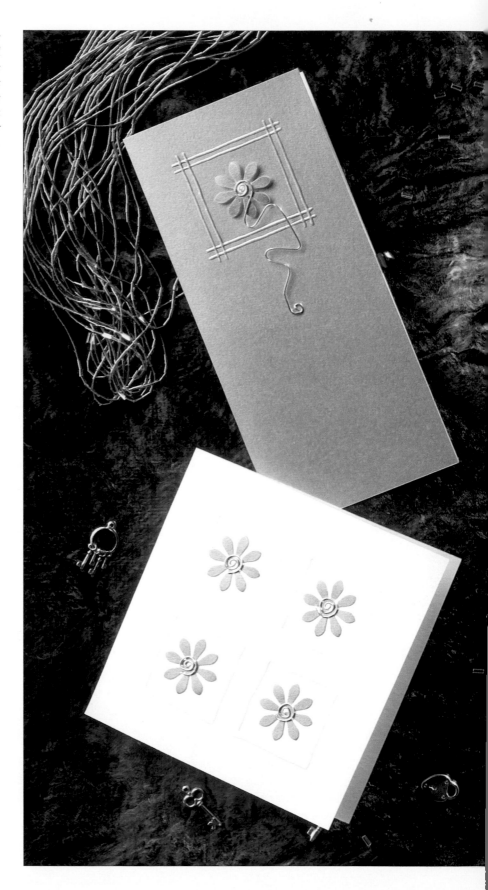

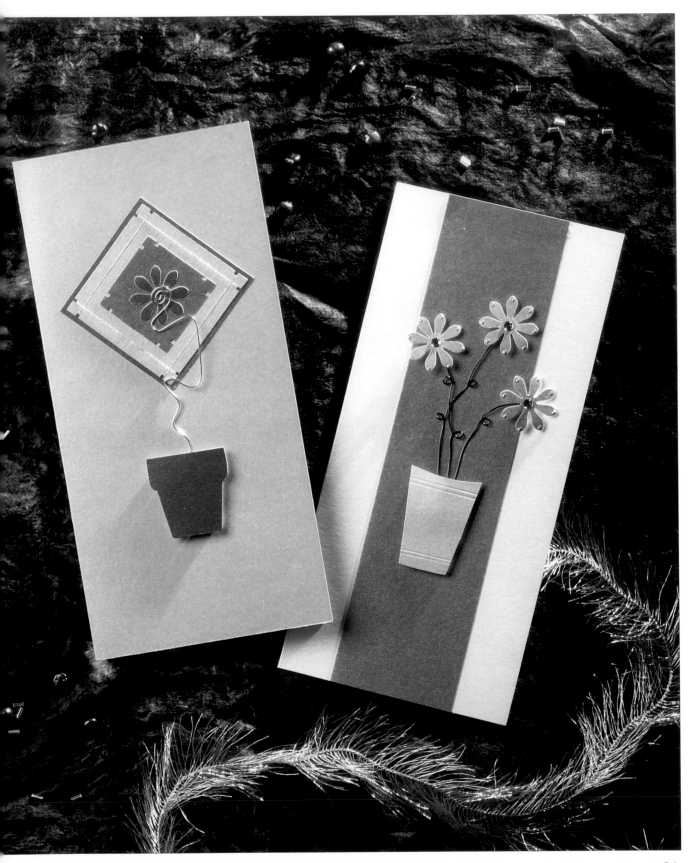

Leafy Luggage Labels

I love these copper tones, combined with the rich lustre of the green card. You will learn how to use the waste from an oak leaf punch to create a rectangular shape with a hole in it, then how to transform this rectangle into a tag, to which you can add a wire flourish. You will also use your punches to make stencils, and sponge through them to decorate the background of your card. Leaf cards make great masculine cards.

You will need

Oak leaf and rectangle punches

3mm (⅛ in) hole punch

22g copper wire and wire cutters

Round-nosed pliers

Copper card blank, 12cm (4¾in) square

Emerald sparkle card and scrap card for stencil

3D foam squares

Scissors

Set square

Pearlescent ivy inkpad

Cosmetic sponge

1. Punch out a leaf shape from a piece of scrap card, to make a stencil.

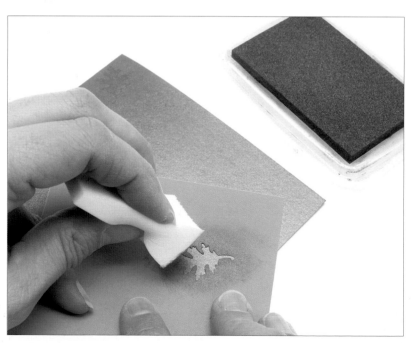

2. Use a piece of cosmetic sponge and a green inkpad to sponge through the stencil onto the copper card blank. Place the leaf shapes randomly, upside down too, and make sure that some go off the edge of the card, for a natural look.

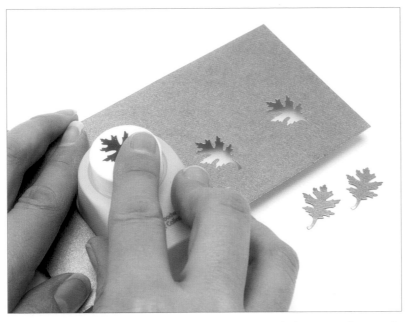

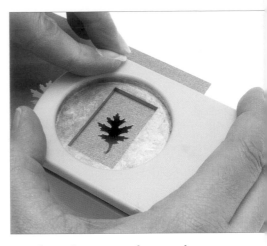

4. Place the rectangle punch upside down around the punched-out leaf, and punch.

3. Punch leaves out of emerald sparkle card, leaving plenty of space between each leaf.

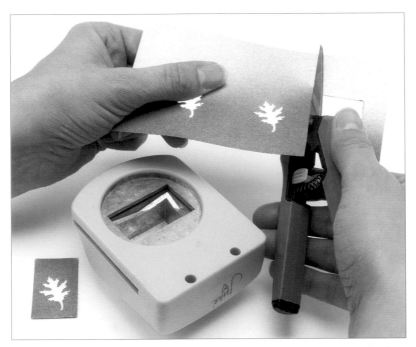

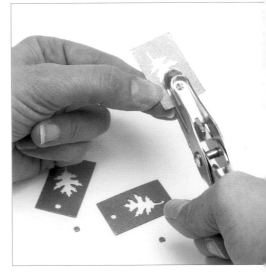

5. Cut away the part of the card with the rectangle punched out of it. This allows the punch to go into the card and align the next punch. This is a way of using the waste.

6. Punch two more rectangles in the same way. Then use the 3mm ($\frac{1}{8}$ in) hole punch to punch a hole in the top of each rectangle. .

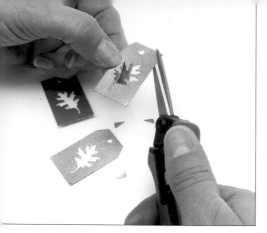

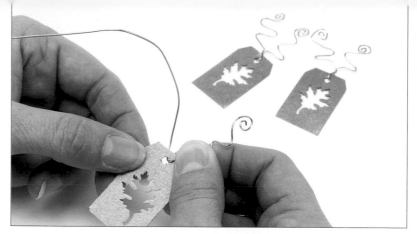

7. Snip the top corners of each rectangle to create a luggage label shape.

8. Thread a length of copper wire through the hole in a luggage label. Use round-nosed pliers to start to coil the end, then use your fingers to shape it. Twist the wire over, then trim the other side with wire cutters and shape it in the same way.

Tip
Snip one luggage label to your satisfaction, then put it on top of the others as a guide when snipping them.

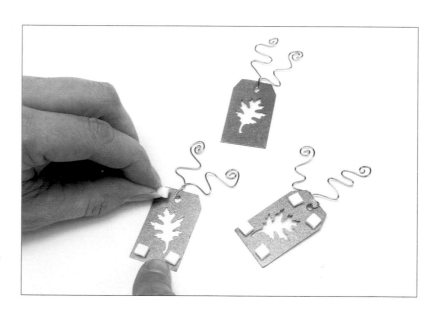

9. Place 3D foam squares to the back of the luggage labels.

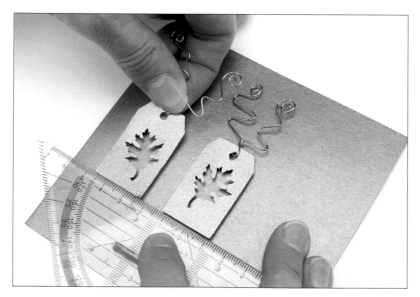

10. Position the luggage labels on the stencilled card using a set square. Place the middle label first.

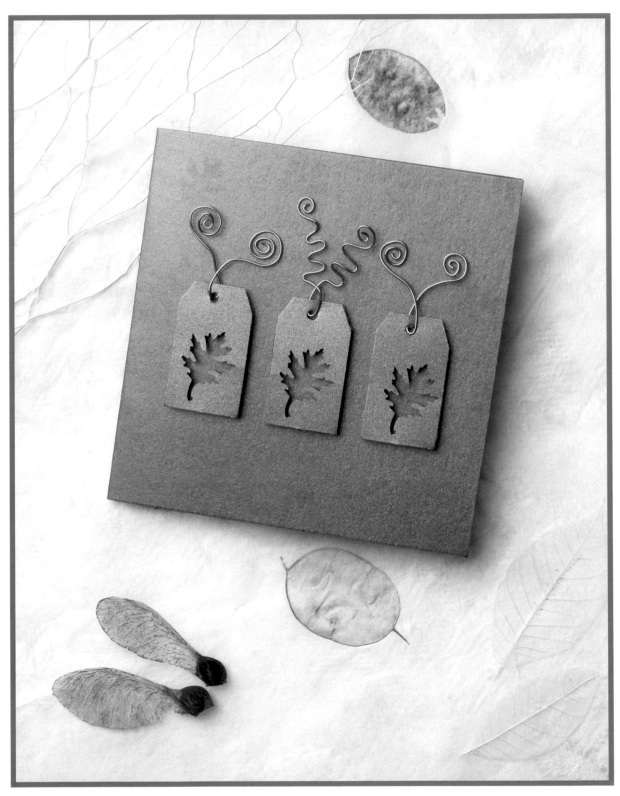

Rich colours and shapes from the natural world are perfectly set off by the luggage label motif in this simple but effective card.

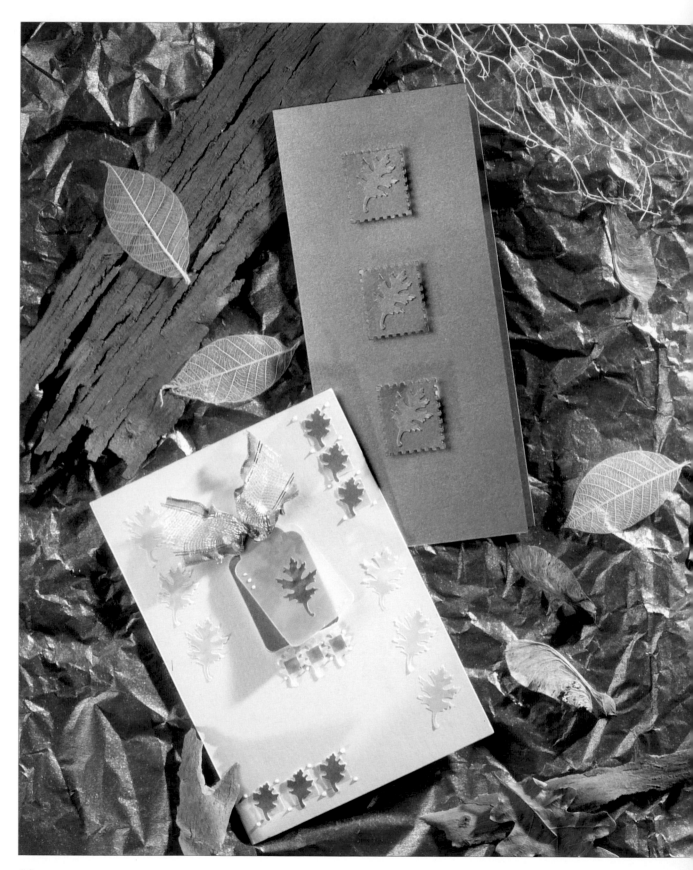

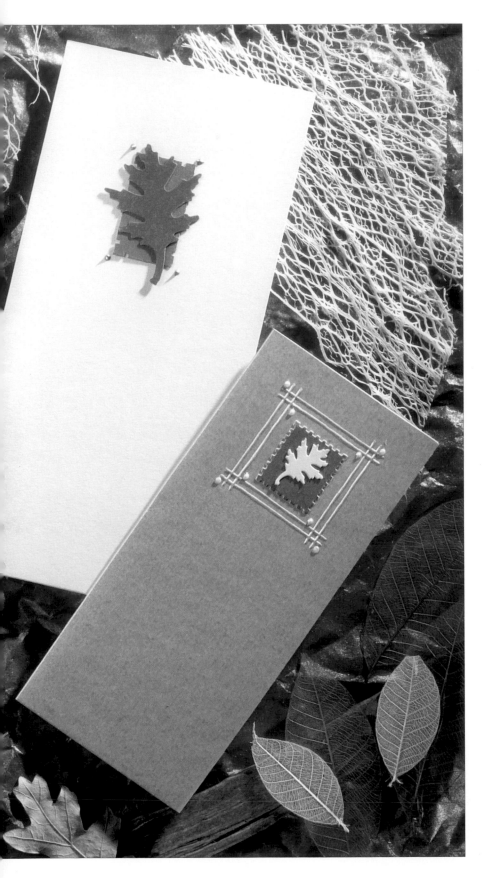

More leafy wonders to inspire you to change the look while using the same punch. The colours are all variations on a natural theme, from soft pearl greens through to the rich lustre of dark copper. The card on the bottom left combines delicate vellum papers with pearlescent card and oak leaf punches in different sizes.

Handbag

I love these handbag shaped card blanks. They are a good way to give vouchers or money gifts to little girls – or even big ones! You can decorate them in a fun, funky way, or dress them up for a more sophisticated look.

This project uses a funky daisy punch combined with square punches, and for the centres of the daisies I have added a crystal for that added sparkle. Decorate a tag to match for a special message, and finish off with threads and beads.

You will need

Daisy punch, daisy corner punch, luggage label punch and 3mm (1/8 in) hole punch

Square punches in medium (2.5cm/1in), small (2cm/¾in) and tiny (13mm/½in)

Lilac sparkle handbag card blank

Lilac and silver sparkle card

Sticker machine and embossing tool

Flat-backed crystals

Glue pen

Purple and oyster dimensional paint

Dimensional glue

22g silver wire, wire cutters and round-nosed pliers

Purple seed beads

Decorative thread

Scissors

Set square

1. Punch out six silver squares using the medium square punch.

2. Punch out six small lilac squares.

3. Punch out six daisies in silver card.

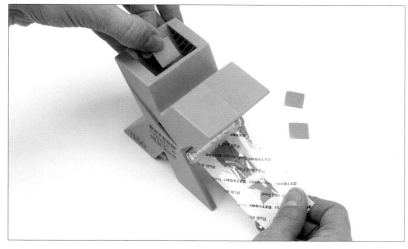

4. Feed the purple squares into the sticker machine and pull the paper through.

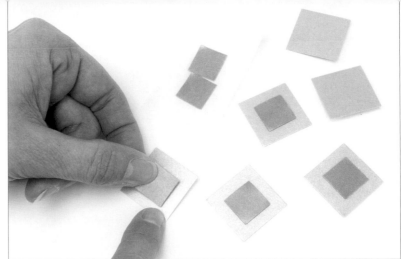

5. Tear off the strip and rub round the edge of the squares with an embossing tool to firm the glue. Then peel back the transparent film backing.

6. Stick the small purple squares on to the medium silver squares.

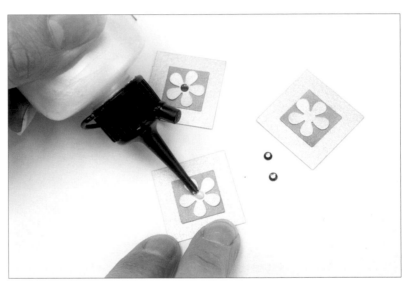

7. Put the silver daisies through the sticker machine in the same way and stick them to the small purple squares.

8. Apply a tiny drop of dimensional glue to the centre of each daisy and stick a flat-backed crystal on to each one.

Tip
Lick your finger and the crystal will stick to it, then you can place it easily on the card.

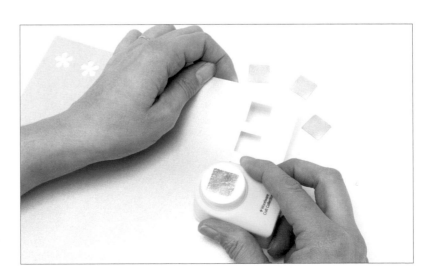

9. Punch out fourteen small silver squares.

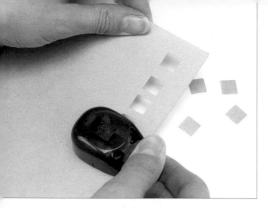

10. Punch out fourteen tiny purple squares. Use the sticker machine to stick them to the small silver squares.

11. Use the daisy corner punch fourteen times on silver card, as you will need fourteen of the largest daisies it cuts.

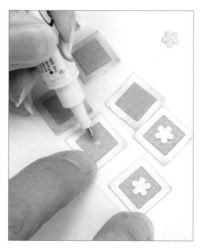

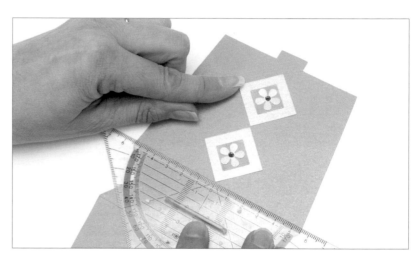

12. Stick the corner punch daisies to the tiny purple squares using a glue pen. Apply the glue to the purple square, not the daisy. You may want to use tweezers to pick up the daisies.

13. Use dimensional glue to stick flat-backed crystals to the centres of the large daisies. Put the medium silver squares through the sticker maker. Rub round the edges with an embossing tool as before. Position the central silver squares on the handbag card blank as shown, using the set square.

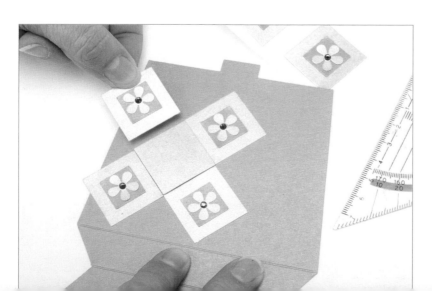

14. Position the other sticky silver squares, using a blank silver square in between as a guide.

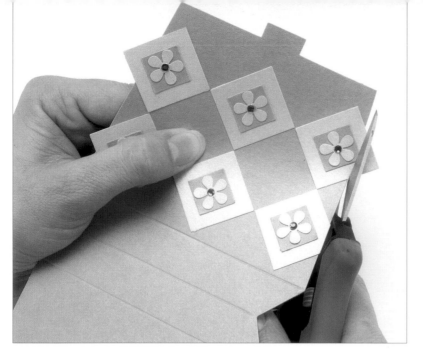

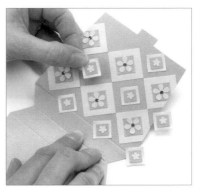

16. Stick small squares in between the medium squares.

15. Trim the edges of the punched squares that overhang the handbag card blank.

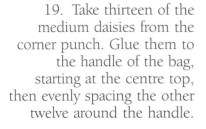

17. Trim the edges as before. It is easier to trim from behind. Fold the bag at the bottom and trim the overhanging edges here, too.

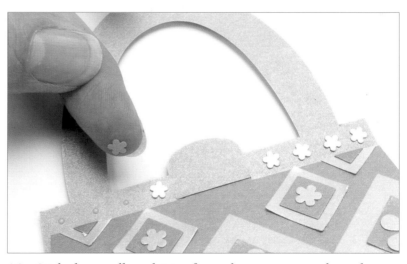

18. Stick the smallest daisies from the corner punch to the top of the bag – four each side, with the glue pen.

19. Take thirteen of the medium daisies from the corner punch. Glue them to the handle of the bag, starting at the centre top, then evenly spacing the other twelve around the handle.

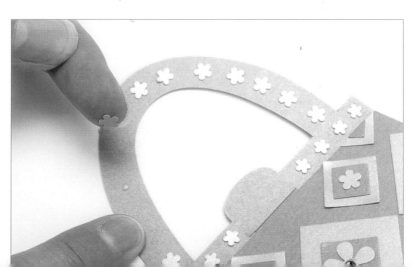

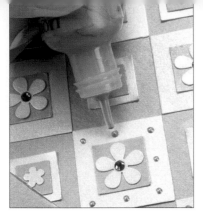

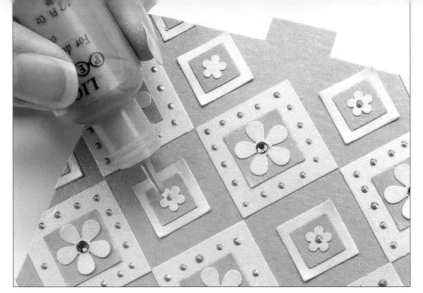

20. Put purple dimensional paint on the medium silver squares: the four corners first, then the centre of the sides, then one either side.

21. Apply purple dimensional paint to the centres of the little silver daisies.

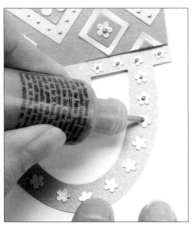

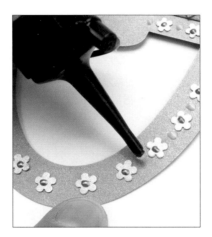

22. Put centres in the daisies on the handle using purple dimensional paint.

23. Apply dots of oyster coloured dimensional paint all around the square purple spaces between the silver squares, then in between the flowers on the handle.

24. Leave the dimensional paint to dry: it is touch dry in twenty minutes but should be left for seventy-two hours to cure. The clasp decoration is a tiny silver square with a purple daisy and a flat-backed crystal in the middle. Stick it on with dimensional glue and apply a purple dot at each corner.

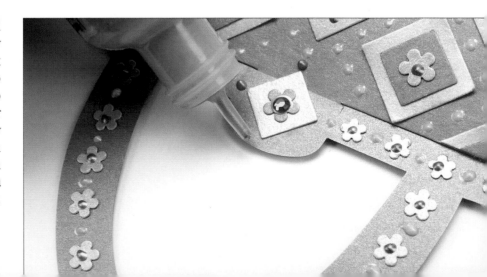

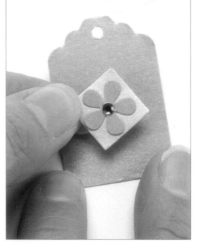

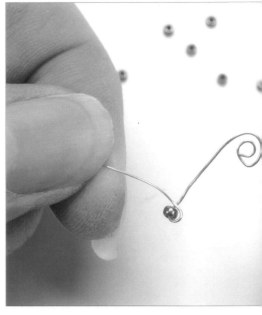

25. To make the tag, punch out a luggage label from lilac sparkle card. Punch the hole with a 3mm (1/8in) hole punch.

26. Punch a small silver square and a large purple daisy and add a flat-backed crystal. Put the decoration through the sticker machine and stick it to the label. Decorate round the edge with oyster coloured dimensional paint and leave to dry.

27. Cut a length of 22 gauge silver wire, spiral the end with round-nosed pliers. Thread on a seed bead and twist the wire round the bead with your fingers. Thread eight to twelve beads in the same way, randomly along the wire.

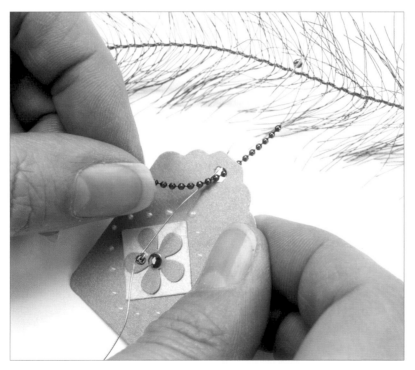

28. Cut two different pieces of decorative thread to the same length. Put them together with the beaded wire and thread them through the hole in the tag.

29. Tie the tag around the handle of the handbag.

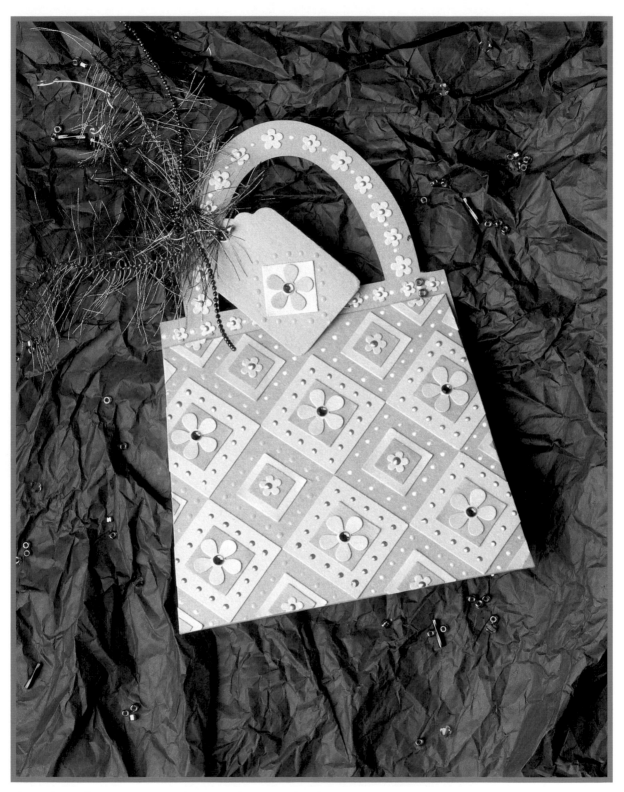

This card is my favourite since it combines everything I love: handbags, crystals, daisies – and it's purple, too! The design features simple squares and daisies yet creates a very ornate effect, and the crystals and dimensional paint add to the sumptuous, bejewelled feel of the card.

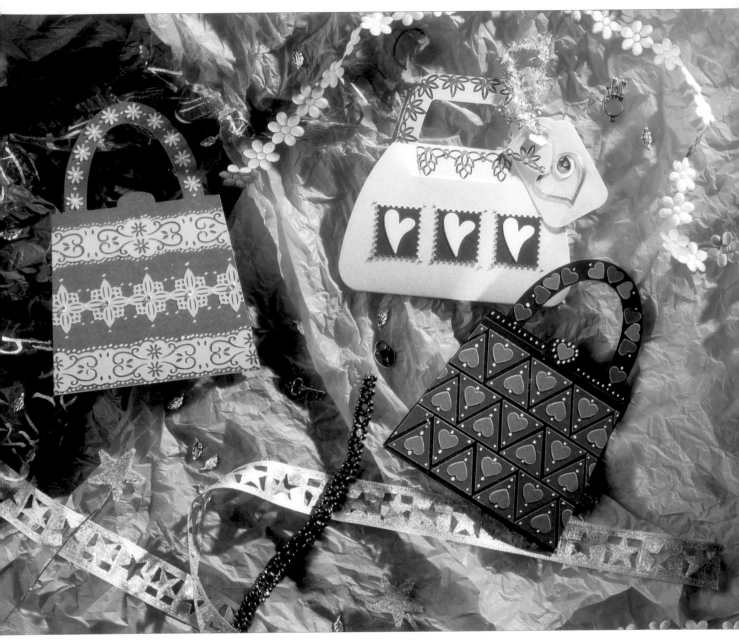

By changing the shapes and colours you can create quite different effects, as in the heart and triangle handbag card on the right. The pink heart card is much quicker to make, with its Peel-Off decoration, and the card on the left uses intricate mosaic and border punches to create a Middle Eastern style.

Christmas Trees

This card would not have been possible without the amazing long reach punch system which extends into the card by 15cm (6in). This enables you to punch wherever you want to on your card. The punch system includes various dies for punching and also embossing dies for creating raised patterns on the card.

You will need

Long reach punch system and tree die punch

Star plier punch

Vintage metallic cobalt gold triangle card blank

Gold card

Glue pen and tweezers

White pencil or silver pen

Set square

1. Find the centre of the card using a set square and make a mark with a white pencil or silver pen. Mark points 2.5cm (1in) apart along the bottom of the centre triangle. Place the next row of marks 2.5cm (1in) above the bottom row, and in between the first marks.

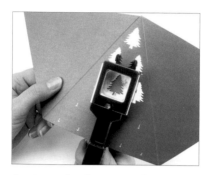

2. Use the long reach punch system with the tree die in it and punch upside down so that you can position the die over one of your marks. The base of the trunk should cover your mark.

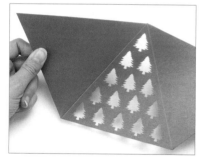

3. Punch out all the tree shapes in the same way.

Tip

This is an easy card to make once you have marked the spacing needed for the positioning of the trees. If I was going to make more than one card, I would use the first card as a stencil, lay it on top of another card and punch through the holes.

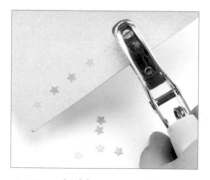

4. Punch fifteen stars from the gold card using a star plier punch.

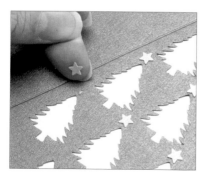

5. Using a glue pen, stick the stars in place above the trees. You can place the stars with tweezers if required.

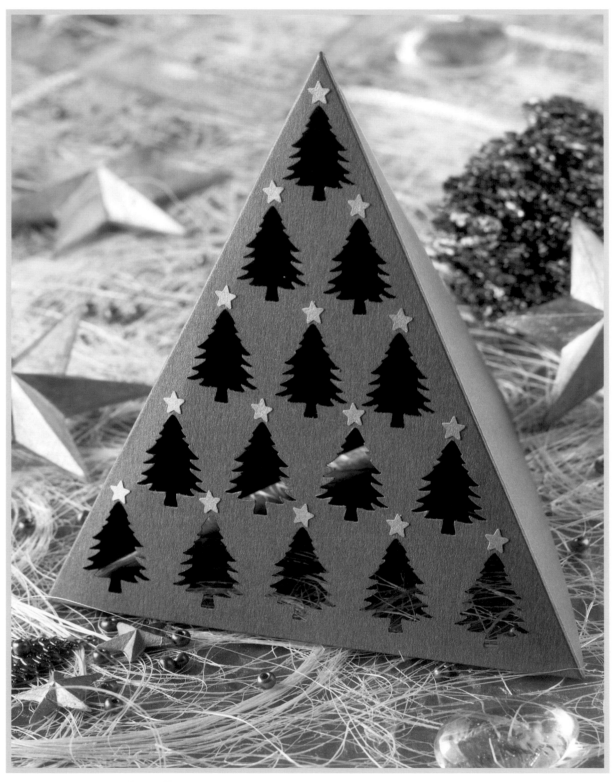

This card is as simple as the handbag card is ornate, and yet with its pyramid shape and subtle sparkle, it will really stand out from the rest. Experiment with fewer holes, different shapes, and ways of using the punched out shapes.

The blue tree tags are mounted with 3D foam squares to raise them off the card, and I added Peel-Off stars to the tops of the trees. The green trees are punched out trees from metallic card, and are mounted directly on to a pearlescent white card for a subtle but beautiful effect. The purple card uses the shapes punched out of the silver card – two cards for the price of one!

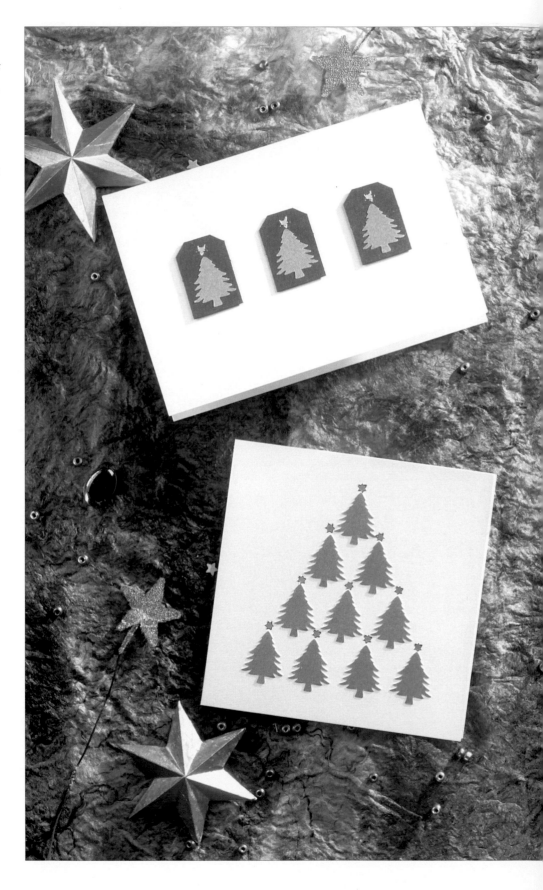

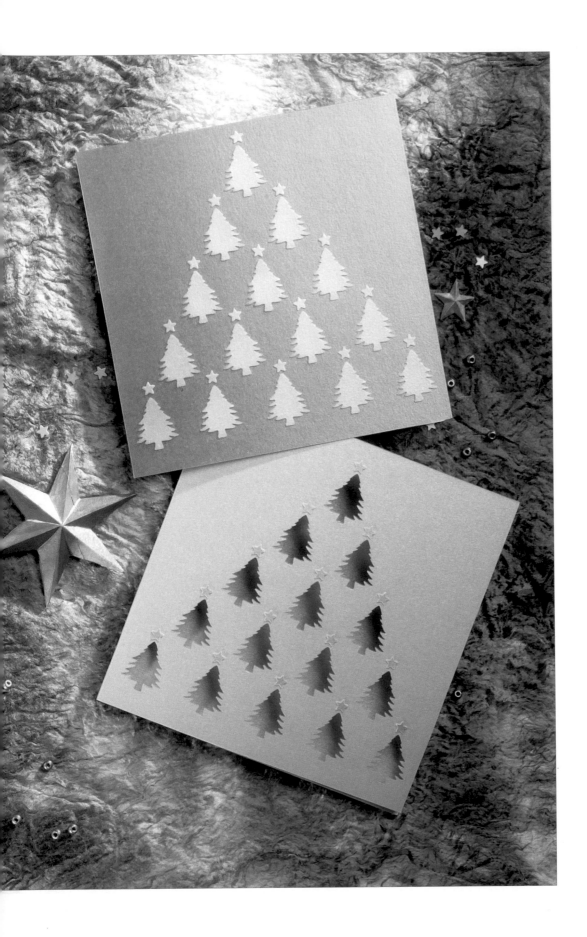

Mosaic Card

These intricate mosaic punches are amazingly versatile, and you can achieve stunning effects with them. They look wonderful with glitter or foil showing through the holes. With careful alignment you can join the squares to create large patterns. You can also punch the patterns in strips and cut the edging off. The punches can be used to make mosaic squares which look like tiles, and when mounted on to another colour card, they will let the colour beneath shine through to great effect.

This project shows you how to link four patterns together and how to punch individual tiles out to create a beautiful border around the card.

You will need

Square mosaic punch

Paper trimmer

Turquoise paper

Turquoise card blank, 12cm
(4¾in) square

Quartz paper

Spray mount and
cardboard box

Tip
These punches are very detailed and will not punch through card. Use them for paper only and they will stay sharp.

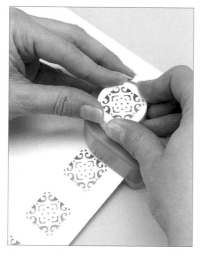

1. Punch out twelve quartz-coloured mosaics with enough space between them to trim round later.

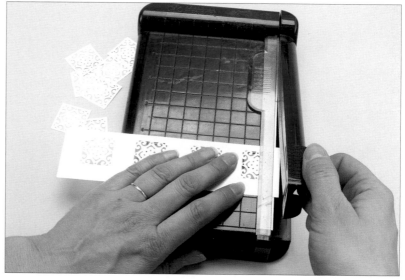

2. Trim with a paper trimmer to leave a 2mm (⅛in) border round each square.

3. Place the squares in a cardboard box and spray with spray mount.

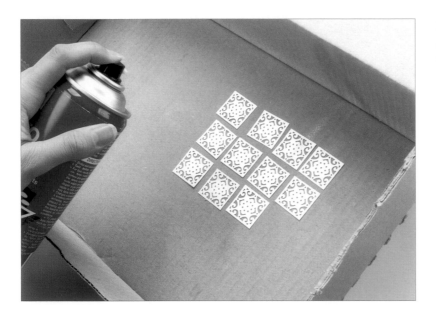

Tip

I always use either spray mount or the sticker machine when mounting the mosaic punches as they are too fiddly to add glue to.

4. Position the squares on your card blank. Place the corner squares first, then the squares in between.

5. Cut a piece of turquoise paper 7.5cm (3in) wide. Punch out the first square with the edge of the punch lined up with the bottom of the paper. Push the paper in as far as it will go.

6. With the punch upside down, line up the edge of the paper with the edge of the punch. Push the paper in as far as it will go and punch again.

7. Line up and do the fourth punch to complete the square.

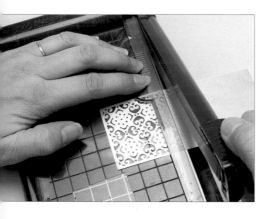

8. Use the paper trimmer to cut to size, leaving a small border around the square.

9. Cut a piece of quartz paper 2mm (¹⁄₈in) larger than the turquoise square. Spray mount the turquoise piece to your quartz square, and the quartz square to the turquoise card.

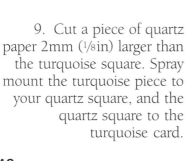 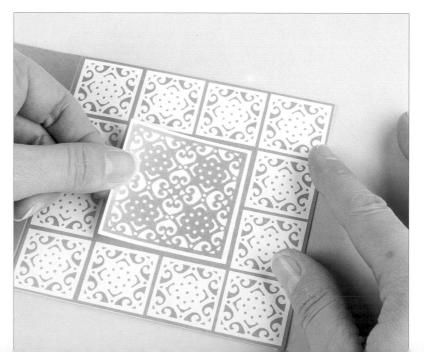

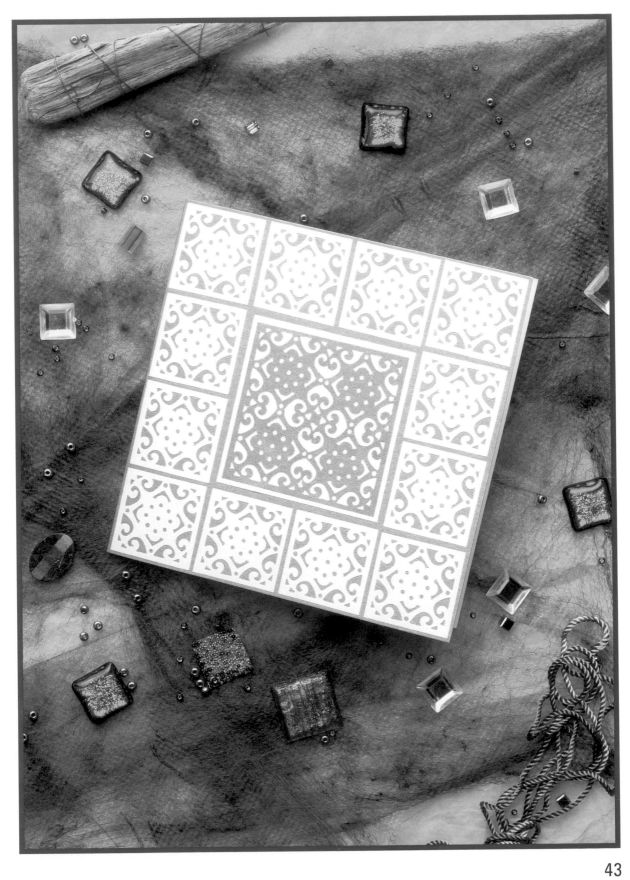

The tall silver card has a strip of mosaic squares punched out. I stuck wide double-sided tape to the back of the strip so that the front of the card, in between the punched holes, was sticky. I then placed a piece of special foil on top of the card and used an embossing tool to trace around the pattern. The foil stuck in all the holes, illuminating the punched strip in gorgeous metallic colours. I added flat-backed crystals to finish the look. The cream and gold card is made from four strips stuck around a square card. The centre four patterns are mounted on to the card with 3D foam squares to add dimension to the card. The blue card uses the same punch as the card on the previous page, in a simpler but equally effective design. The deep red card features pale pearlescent and metallic gold squares set at different angles, and is finished by dots of gold dimensional paint like tiny rivets. It could be the lid to a beautiful treasure chest!

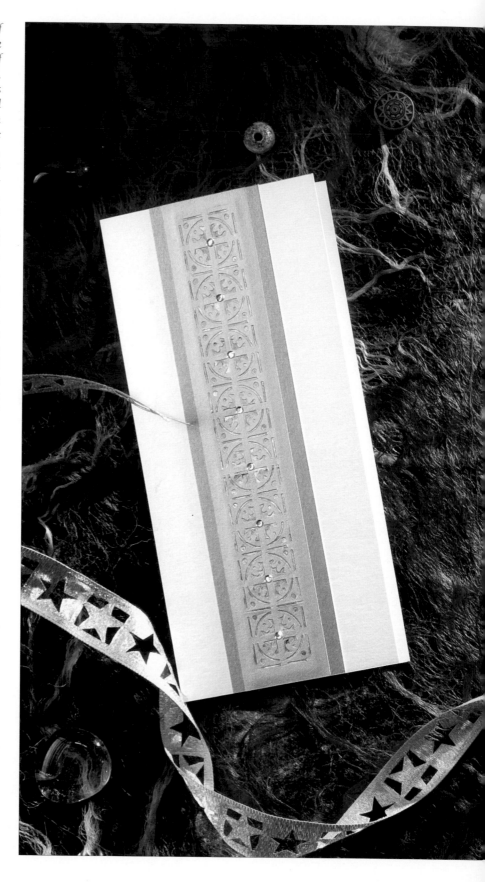

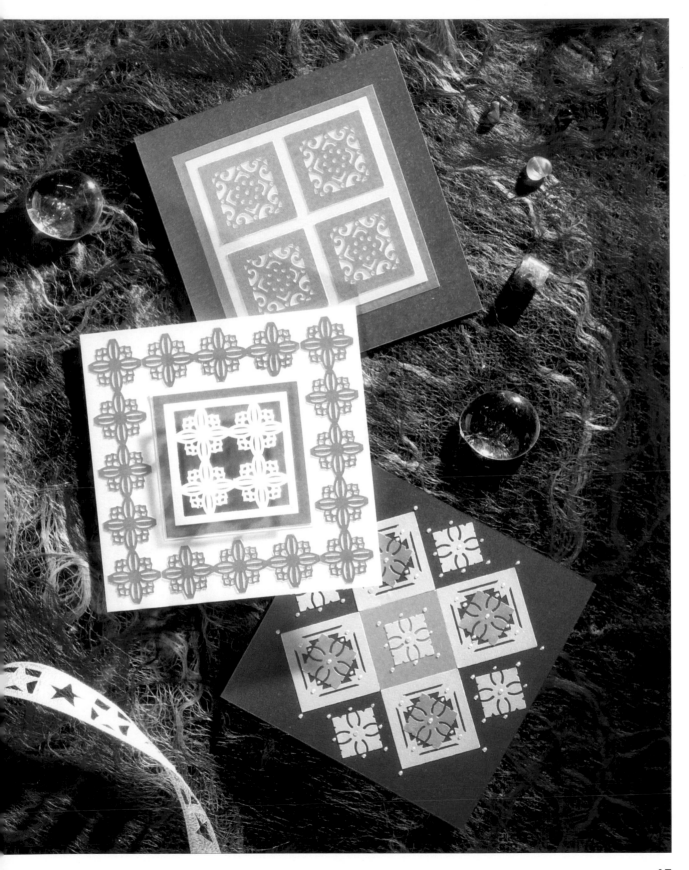

Further ideas

The tall sparkling grey card has a rubber stamped frame around the daisy, and the pot is made from card dyed using an inkpad. For the three-daisy card I varied the look by mounting the pots and flowers on 3D foam squares to make them stand out. I layered different sized daisies in gold and copper card for a bright, metallic effect, set off perfectly by the twisted copper wire.

Acetate creates a whole new dimension to your card making: it can be used as the basis for the card itself, or can be added for a sleek, shiny finish. The acetate card in the middle of the picture has punched squares and flowers stuck to the inside, and flower-shaped holes punched out of the front. The card at bottom left is made from a purple card decorated with punched shapes, stuck inside an acetate card. Punched out daisies with crystal centres are then stuck to the front of the acetate card so that they stand out from the background in an unusual but quite beautiful way. The red card with the leaf motif at bottom right is lovely in its own right, but the acetate adds a wonderful shine.

The black card is one of my all-time favourites! It came about when I bought a block of paper all the colours of the rainbow. I punched a square from each colour, added a white daisy with a yellow centre and hey presto!

The black, pink and purple card was made using only square punches in lots of different sizes. I highlighted the squares with dimensional paint to add interest.

Now see what you can do – get busy and get creative but above all, have fun with your punches!

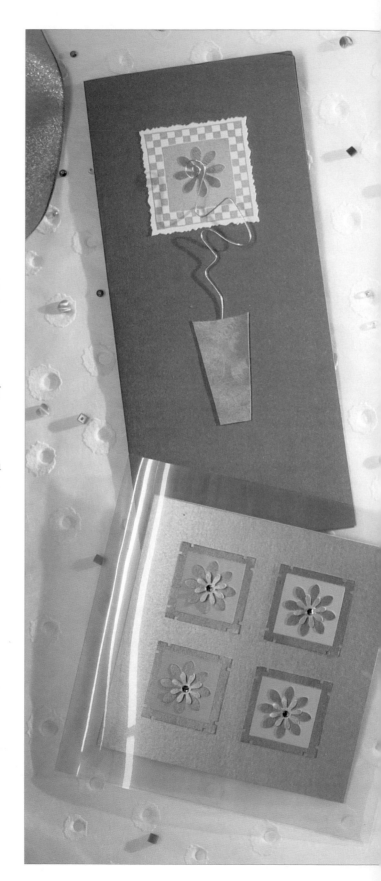

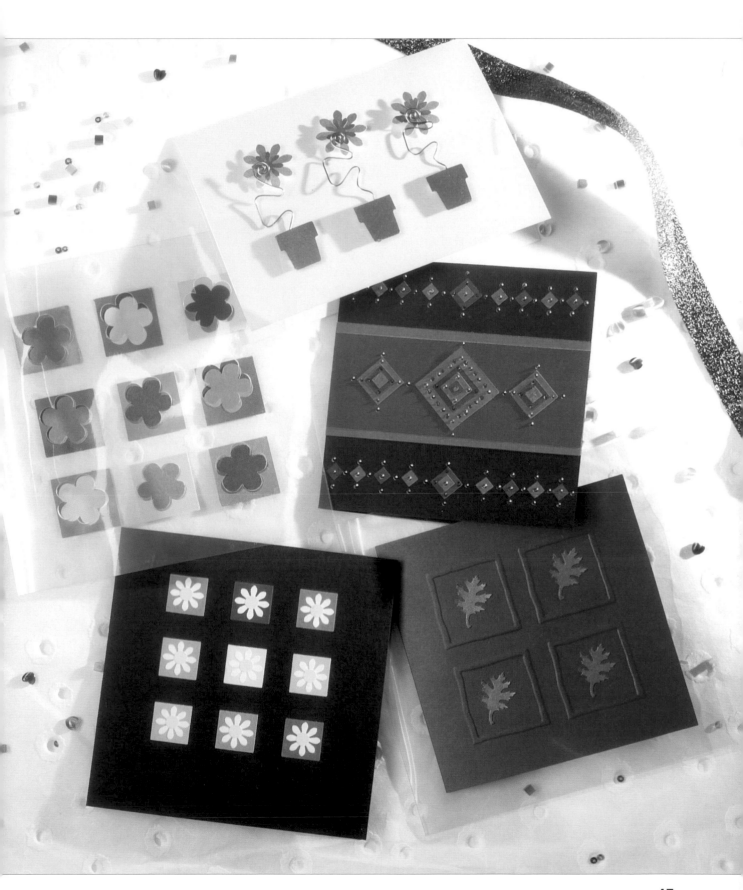

Index

acetate 46

beads 6, 10, 11, 28, 33

crystals 10, 19, 20, 28, 29,
30, 32, 34, 44, 46

diamonds 12, 20

embossers 9, 36

foil 40, 44

glitter 40

long reach punch system 9,
36

position 11, 18, 24, 30, 41
punch aids 9

punches
 border 8, 14, 35
 circle 8
 corner cutter 16
 daisy 6, 14, 16, 17, 28,
 34, 46
 daisy corner punch 28,
 29, 31
 flower 15, 46
 flowerpot 20
 heart 13
 long reach 8, 36
 luggage label 28, 33
 oak leaf 22, 27
 mosaic 8, 35, 40–43, 44
 plier 8, 36
 rectangle 23
 square 6, 8, 12, 13, 14, 16,
 28, 29, 30, 46
 star 36

thumbnail 8
tree 36–38

rectangular aperture 6,
 12–13

square aperture 6, 12–13
sponge 11, 15, 22
stencils 11, 15, 22, 24, 36
sticker machine 11, 28, 29,
 30, 33, 41

thread 6, 16, 17, 19, 28, 33

waste 6, 14, 22, 23
wire 6, 10, 11, 16, 18, 19,
 20, 22, 24, 28, 33, 46